TODD WALKER
PHOTOGRAPHS

WITH AN INTRODUCTION BY
JULIA K. NELSON

UNTITLED 38

THE FRIENDS OF PHOTOGRAPHY

THE FRIENDS OF PHOTOGRAPHY

The Friends of Photography, founded in 1967, is a not-for-profit membership organization with headquarters in Carmel, California. The programs of The Friends in publications, grants and awards to photographers, exhibitions, workshops and lectures are guided by a commitment to photography as a fine art, and to the discussion of photographic ideas through critical inquiry. The publications of The Friends, the primary benefit received by members of the organization, emphasize contemporary photography yet are also concerned with the criticism and history of the medium. They include a monthly newsletter, a quarterly journal and major photographic monographs. Membership is open to everyone. To receive an informational membership brochure, write to the Membership Coordinator, The Friends of Photography, Post Office Box 500, Carmel, California 93921.

UNTITLED 38

This volume is the thirty-eighth in a series of publications on serious photography by The Friends of Photography, P. O. Box 500, Carmel, California 93921. Some previous issues are still available.

ISSN 0163-7916
ISBN 0-933286-42-2
Library of Congress Catalogue Number 85-70352

Designed by Todd Walker and Rebecca Gaver.
Color Separations by American Color Corp.
Printed by Fabe Litho Ltd.
Digitally Typeset by Kennedy Typography.

Cover: *Agave maguey, 1983*, left portion. Lithograph (actual size).

ACKNOWLEDGEMENTS

This book is the result of an unconventional collaboration between the artist, publisher and printer. While the innovative work of Todd Walker remains the subject of this volume, the artist himself has played the major role in the book's creation, serving as its subject, designer and director of production. Walker is not unacquainted with the artist's book having produced a number of handsome volumes on his own press. While this project is of a dimension, and has a press run well beyond the capability of his small press, Walker beautifully choreographed and closely supervised every aspect of the publication. We would like to thank him for the many hours he devoted to this project.

This artist's book would not have been possible without the support of a grant from the Visual Arts Program of the National Endowment for the Arts. Also essential to its evolution was Julie Nelson, who wrote the introductory essay and enthusiastically gave her time and energy to the coordination of the publication.

Thanks are also offered to the entire staff of The Friends of Photography. Special recognition must go to David Featherstone for his role in the development of the project and for his editorial assistance, and to Claire V. C. Peeps and John Breeden for their help with the manuscript. The artist wishes to thank Rebecca Gaver for her part in the design and final production of the book; and Julie Nelson gratefully acknowledges David A. Gal, who spent many hours transcribing interview tapes and lent his assistance whenever needed.

Most importantly, it is through this book and the accompanying retrospective exhibition held in Carmel in early 1985 that The Friends of Photography is able to acknowledge Todd Walker's artistic contribution and dedication to the field of photography.

JAMES ALINDER, Editor
The *Untitled* Series

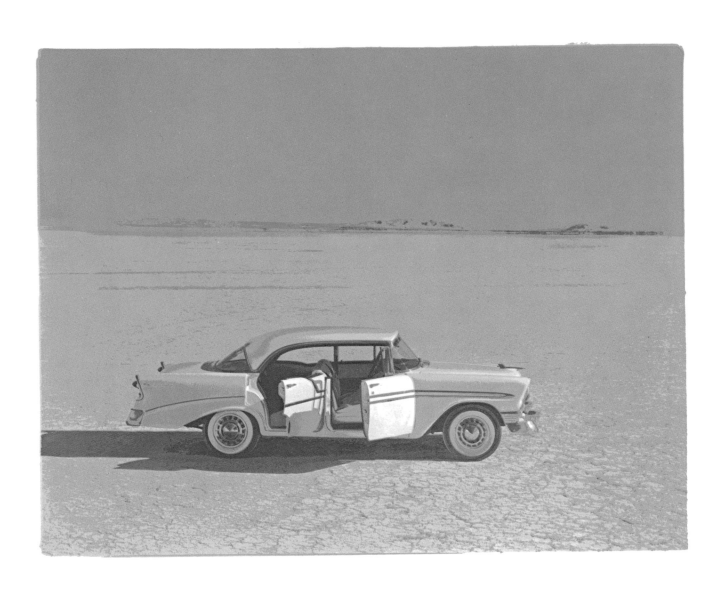

Chev, 1955/1975. Silkscreen (38.0 × 48.5 cm)

INTRODUCTION

BY JULIA K. NELSON

I N the mid-1960s, after twenty successful years as a commercial photographer, Todd Walker began an intensive exploration of his creative vision, utilizing a variety of photographic processes, materials and imagery. Unlike most artists, he did not establish a single format, medium or style in which to work, but varied his approach greatly depending on the particular set of questions that each image raised. Walker fearlessly ignored the parameters that were widely accepted in photography at that time. Through his extensive experimentation with photographic and printmaking materials and, more recently with computer-generated imagery, Walker has made a lasting mark on the direction of the photographic arts and has influenced a new generation of artists.

Working with an array of complicated new techniques and old processes, Walker's imagery consistently shows a concern for subjective and emotional qualities expressed through the female nude and the landscape. He initially evoked these states of mind by altering both the settings in which he photographed and the final prints, in the vein of a commercial photographer. Later, however, he concentrated on enhancing or subduing certain formal characteristics through manipulation of the materials themselves. In order to create images closer to his own perception than to the camera's limited vision, Walker experimented freely, making use of the Sabattier process and arbitrary colors. This exploratory and often playful interest in the visual possibilities contained within process and image presentation led to his investigation of handmade, limited edition books, and later to the image-making potential inherent in the new computer technologies.

Walker's diverse and experimental approach to photography can be traced to the unconventional route of his career. He did not study for a university art degree, as is the norm today, but rather worked full time, took classes at night and aspired to become a commercial photographer. Born Harold Todd Walker in 1917 and raised in Los Angeles, he studied photography at the Art Center School in that city for two years while working at Hollywood's RKO Studios. At Art Center he was exposed to photography as an art form through the progressive teachings of Eddie Kaminski. Though skeptical then of the practicality of the arts, Walker now sees that experience as one of the most important influences on his personal photography. In 1945, after serving in the army, Walker embarked on a commercial career that would last twenty-five years and bring him a reputation as one of the most competent and versatile commercial photographers, not only on the West Coast

but throughout the United States. He was considered a pioneer in the advertising world for the original photographs he produced for companies such as Chevrolet, and was known for his innate ability to solve a variety of visual and technical problems.

Rather than producing straightforward presentations of car exteriors, as was commonly done, Walker made imaginative photographs for Chevrolet which helped change the course of automotive advertising with their emphasis on realistic settings, natural lighting, performance and a romantic aura. He later reprinted and modified, through the addition of color, one of his earlier, traditional car photographs in order to capture the feeling of the expansive desert environment (page 6). The 1975 print remains a record of his first career while it reflects, by its use of an earlier negative in a contemporary print, his later creative endeavors.

This approach to the medium differs from that of more traditional photographers in that Walker's final product is the result of a synthesis of what is recorded by the camera and the artist's manipulation. Through a constant reinterpretation of his materials and imagery, Walker revitalizes ideas, and is able to control and alter the viewer's response to and understanding of his vision. While he maintains no single formula for manipulating his prints, his method of working has led to a distinct style. Using varied subject matter that includes both human forms and the landscape, his photographs have remained dialogues on human perception and the capabilities of the photographic arts. Walker's interest in the creative process, his enthusiasm for experimentation, his adaptability to specific situations, his productivity and his technical expertise are joined in the creative and influential body of work found in this volume.

In September of 1963, the first one-person exhibition of Todd Walker's photographs opened at the California Museum of Science and Industry in Los Angeles. Shortly thereafter, while on assignment in Mexico in March of 1964, he befriended the inhabitants of a small village and became acquainted with a simpler and more primitive way of life. That year he also acquired a relief printing press and type cases, and this new equipment, combined with the experience in Mexico, encouraged him to devote more time to his artistic photography. He selectively cut back on his highly demanding commercial assignments. For the next five years, until he completely abandoned his commercial career in 1970, Walker spent his free time rediscovering the possibilities inherent in the photographic medium, often relying on sources and processes from the medium's early history.

During this intensive period, Walker explored processes and techniques such as collotype, gum dichromate, kallitype, blueprint and carbon. All of these had been used extensively in the late nineteenth and early twentieth centuries, but were virtually ignored by photographers during the 1950s and 1960s. While he was not completely alone in his efforts to repopularize alternative photographic processes, he certainly did most of the groundwork that led to its resurgence in art schools across the country in the 1970s.

Guided by an 1881 copy of *Wilson's Photographics* that contained helpful but outdated formulas for the production of old processes, he began to experiment with the early photomechanical reproduction method called collotype. He was drawn to the challenge of rediscovering and mastering this lost medium, and its relationship to lithography led him to further explorations using an offset lithographic press. By working on the press he could vary the paper stock, pigments and method of applying the color to suit the needs of a specific image. The press also gave him the opportunity to disseminate his images without relying on outside publishers, and thus intensified his interest in the hand-crafted book. Walker described his ideas about exploring alternative techniques in a conversation with the author in June 1984: "Somewhere along the line I realized that if I found how something works, I could begin to make guesses about it working in another way. Just showing an object in a photograph seemed like a minimal use of the language."

Walker first used the collotype process in 1966 to produce two books. He found the intimacy of the hand-held book to be a good forum for his ideas, and he immediately went to an extreme. *Shakespeare's Sonnets* measures only 2¼ by 3⅛-inches; yet the diminutive size is both attractive and appropriate for these tender verses and images. The preciousness of the book extends beyond its size, however; the small studio nudes are delicately reproduced, and the quality of the leather binding and the hand-marbled cover is superb. This concern for craftsmanship and attention to detail, which continues today in every project he undertakes, was first evident during his time at RKO Studios when, as an apprentice scene painter, his responsibilities included jobs such as accurately matching colors and marbling the fireplace for the set of *Citizen Kane*.

An aspect of Walker's work that developed during this early period and has become closely associated with his imagery is the Sabattier effect. Walker first encountered this technique, often referred to as "solarization," at Art Center School. Accomplished in the darkroom by momentarily exposing photographic film or paper to light before it is completely developed, the process can result in a partial reversal of the black and white tones, sometimes causing a sharp line to appear at the boundary between light and dark areas. The results of this often unpredictable procedure vary greatly in quality and mood from one attempt to the next (pages 17, 22, 23). While several well-known photographers have utilized the technique, few have applied it so consistently, and none has used it to the extent that Walker has.

The majority of the images he made during the late 1960s and the early 1970s had the female nude as the basic subject. While he did photograph outdoors, by concentrating on work done in the studio he had more time to focus on making images rather than on the complexities of travel and changing environments. By photographing models he could have diverse situations within a simple setting. He wanted to create images that were timeless, that could not be held to a specific period by the style of clothing or other

attributes. The nude seemed to be the most ideal realization of these ideas; the female nude, because it was more socially acceptable, became his subject. Walker did not direct models during photography sessions as was necessary in his commercial work, but rather allowed them to communicate through movement and expression. Though he avoided professional models because of their tendency to use contrived poses, he had particular success photographing one artist's model, a retired dancer named Pearl, who had an abundant figure and uninhibited movements. In two sessions Walker obtained several hundred negatives, enough to make numerous prints during this early period, and from which to experiment throughout his career. He has drawn on them most recently in the new computer-generated work.

The empty studio did not always stimulate reactions from the models, so Walker built several restrictive structures. He preferred to photograph in controlled environments, probably as a result of his commercial background, and these structures gave the models something with which to interact, encouraging movement that inspired more varied reactions in their gestures and expressions. With the challenge of fixed lighting and only a few vantage points from which to photograph, his intention to generalize the figure in time through the use of the nude was now extended to a consideration of the figure generalized in space.

A comparison of *Jacque* (page 16) and *Pearl, 6 flavors* (page 18) reveals the photographer's diverse interests in gesture, mood and the human figure. While the nude is the starting point for these photographs, the images' final meanings result from the emotion revealed through the artist's direct manipulation of the materials. The foreboding quality of *Jacque* is attributable to the hazy, uneven surface possible with the gum dichromate process, and to the dark pigments selected. Similarly, two collotypes of Pearl (pages 18, 19) demonstrate the artist's spirited use of image repetition, fragmentation of the figure and the vagaries of the inking process. These seeming "abuses" of traditional, acceptable technique and style emphasize Pearl's movement and create the appearance of the figure spinning across the page. The selectively applied inking produces gestural marks around the head and feet, while the segmentation of the model's body draws attention to the variation in the position of each of these parts. The print of four "Pearls" becomes a homage to the nineteenth-century photographer Eadweard Muybridge, whose *Animal Locomotion* sequences from the 1870s had also been printed by collotype.

Walker continued to explore his interest in arbitrary color and abstraction in a series of work that eventually was combined as *Portfolio III*. In these nudes, mostly of Pearl, Walker reduced the body to a series of outlines by solarizing several versions of an image on lithographic film. Each outline contained slightly different information, and was printed using various hand-mixed inks (page 37). Rather than preconceiving the color combinations, he printed the initial color, then responded to it before mixing the next hue. This

interest in mixing and combining colors dates back to his early job as a painter at RKO Studios, where he playfully combined leftover paints during clean-up.

In January 1970, a few days after ending his commercial career, Walker was offered a position, to begin the following fall, teaching photography at the University of Florida in Gainesville. The job was initially to last one year, so the printing press was left behind. With neither studio nor press, Walker altered the manner in which he photographed and printed, and these changes came to affect the direction of his work.

He adopted the silkscreen process as a viable alternative, though it could not provide the detail and delicacy of line that Walker had become accustomed to in his collotype and gum dichromate prints. He communicated through bold forms and adapted to the medium's inherent qualities but he also learned to force line and detail by means of multiple printings. In one of his first screen prints, *Chris* (page 24), he created a classically composed, sculptural image of a female nude whose pose is emphasized by a dark outline, and whose body is given form through the numerous gradations of color. While still abstracted, her body is contiguous; she has form, and her facial features are subtly detailed by the rust-colored printing. Although this image was well received by viewers, Walker never felt comfortable with its idyllic beauty. A print done two years later, *Calligraphic Alice* (page 25), has many similarities to *Chris*—a strong outline, bold form and some detail—but it is clearly more representative of his surreal vision.

Walker moved away from the depiction of abstract nudes and began to photograph people in their natural environments (pages 26, 27). The models, now defined by their personal surroundings, became more sensuous and relaxed, and his photographs became filled with the details of his subjects' lives. Surrealism remained important in Walker's vision, as he continued to manipulate the image through wide-angle lenses, solarization and the application of arbitrary colors. An interest in gesture was still prominent, though the figures now related to their environments instead of to unfamiliar restrictive settings. Repetition and fragmentation of space remained integral to the artist's statement. He combined images casually, allowing the individual units to dictate the print's boundary (page 27). The growing interest in repetition emphasized his awareness of the reproducibility of printmaking and photographic media, and extended the variety of possibilities open to him with a single negative.

While in Florida, Walker also resumed an earlier interest in plant forms. His respect for the work of Edward Weston and his awe for the view camera work of traditional landscape photographers had previously restrained him from using the landscape in an experimental way; he now fully incorporated it into his work. In *To Linda Connor* (page 29), which pokes fun at a colleague whose own photographs, while symbolic, are rendered through classic, large-format, black and white techniques, he presents two individually successful solutions to printing the same negative. The left image is contained and colorful,

and has a close relationship to visual reality. In contrast, the image on the right is a free and expressive study in line that explores beyond its original boundaries. As in *Tallahassee trees* (page 28), the separate parts gain strength as they play off each other and encourage the viewer to study the image more closely.

After this investigation with a surreal and abstract vision, Walker gradually returned to making prints that had a direct visual reference to the photographic medium by including more image details and dark borders. He became engrossed with the idea of creating a screen print that resembled a photograph (pages 30, 31), and his experiments led to the application of as many as sixteen layers of subtly varying color. The effort put into generating these highly photographic prints is reminiscent of the nineteenth-century lithographers who used many printings to achieve a delicate rendering. Walker once again displays in these silkscreens an intensive interest in and complete command of the process in which he chooses to work.

By 1975 Walker had gained a national reputation as an artist that paralleled his recognition as a commercial photographer some fifteen years earlier. He received a National Endowment for the Arts Photographer's Fellowship in 1971, and had many one-person exhibitions, including shows at The Friends of Photography Gallery in 1970 and the Rhode Island School of Design in Providence in 1972. He was included in the Museum of Modern Art's 1971 exhibition *Women* and the Whitney Museum of Art's 1974 show *Photography in America*, both in New York City. During this time his influence on the expressive possibilities available within the photographic medium was felt nationwide, particularly in college and university photography programs.

In 1976 the purchase of a more advanced offset press expanded his capabilities, and prompted the production of two books in larger limited editions, *for nothing changes...* (905 copies) and *A Few Notes* (700 copies). *For nothing changes...* contains lithographs of nudes and, as described on the title page, "some words from *Anatomy of Melancholy* by Robert Burton (1652); others from your local news service" (page 36). In the afterword Walker writes, "These words are not captions. The photographs are not illustrations. However, please feel free to try to connect these any way you can possibly imagine." The lithographs vary in mood, with many of the nudes sensuous, some abstract and a few surreal. Burton's writing on Democritus moves the reader through the book linearly while the insertion of the modern "news" between the lines of his text forms concrete poems. Readers accepting Walker's invitation to find relationships between the news, text and images on each page may invent numerous connections.

A Few Notes contains images of nudes and short notes of advice on the photographic medium that were originally published in *Wilson's Photographics*. The selection of notes provides elegant insights into Walker's thoughts as an artist. One clearly makes reference to the freedom of expression he relished having mastered his many techniques: "When the

artist is interested in his work, and believes in his art, it becomes wonderfully plastic, and the materials wonderfully tractable in his hands." Bookmaking had become a means for Walker to disseminate his images and ideas in an intimate, non-commercial form.

In 1977 Walker accepted a teaching position at the University of Arizona in Tucson, where he moved in August of that year. His interest in artists' books and portfolios continued with an ongoing concern for the nude, for the multiple solutions possible in creating an image and for the way in which the viewer perceives a photograph. A portfolio of photographs entitled *Fragments of Melancholy* was produced in 1980 that synthesized words, images, decorative design elements and historic illustrations (page 38). These beautifully constructed prints are romantic in both their subject and their presentation. The text, again excerpted from Robert Burton's *Anatomy of Melancholy*, is combined with Walker's images; the presentation has affinities to early manuscript illuminations.

In returning to the Southwest from Florida, Walker felt more comfortable with both the weather and the vegetation. This generated an enthusiasm for photographing the landscape and prompted him to focus more attention on studying his natural surroundings. While relying now on the readily available desert landscape, he continued to transform seemingly innocuous plants and settings into expressive forms. Walker searched for rocks and other elements of nature that possessed human characteristics, and then accentuated these qualities through modifications of the print. In one lithograph (page 39), flesh-toned ink has been used for printing the torn and inset image, furthering its resemblance to nude torsos.

Walker now began to alter color in very subtle ways as in *Yucca II* (page 41), one of a series of close-up plant studies. The hue in the middle of this print has been changed, and through slight variations Walker draws the viewer into the photograph and focuses attention on the way color can alter the subject. This modification of the landscape became bolder in *Alamogordo* (page 43).

The later landscapes also illustrate Walker's continuing love of line, but instead of the bold, often isolated lines used to define the earlier nude figures, these landscapes are primarily composed of a colorful and intricate net of Sabattier lines. It is the lines and details inherent in nature that seem to hold greater attraction to Walker now, rather than the form and movement that were dominant in earlier photographs such as *Tallahassee trees*. While the modification of both the image and the viewer's perception are still primary themes in these later landscapes, the photographs bear a closer resemblance to visual reality than did the earlier depictions of the land.

Throughout his career Walker has worked on several projects simultaneously, and now, having reached the age when most people in our society retire, he has added to his repertoire one of the most technologically advanced forms of image-making. After two years and hundreds of hours writing programs for his Apple computer in the assembler

language, he is able to digitize an image into a pattern, and can alter and recombine both color and imagery using simple commands. Photographing an image with a video camera, he feeds information into the computer and manipulates it. Because he sometimes chooses to gather information from already existing photographs rather than directly from reality, many of his initial computer-generated photographs are reinterpretations of early prints; the images of Pearl were among the first subjected to computer transformation. Walker characteristically took his new medium to its limit, and photographs from 1982, such as *Computer II* (page 45), are reminiscent of the greatly abstracted images produced by his earlier experiments in other media.

Walker constructed images to define visually the computer-generation process in the same manner that he directed his exploration of other processes. In *Agave maguey* (cover), Walker escorts the viewer through a labyrinth of interpretations of the agave plant and the photographic medium, with the computer-digitized portion remaining the most greatly abstracted. He continued this quest in a lithographic series of plant studies that incorporates both a photographic and a computer-generated image in the same print (pages 46, 47). The final product, a combination of two approaches in one image, demonstrates the diversity of the artist's interests and his concern for describing visually both process and interpretation.

Walker has "digitized" these photographs in two senses of the word. The image was broken down into several separate negatives, each of which contains slightly different visual information that he recombined during printing using various colored inks. This elaborate process of breaking down and reassembling has been integral to Walker's explorations with photography since the 1960s, and it can now be seen as an important element of the further digitization of an image through computer processing.

Through two careers spanning almost five decades, Todd Walker has maintained a youthfulness in his approach to the photographic medium that remains evident in his work today. In the 1950s, it was Walker who helped revitalize the automotive advertising industry with his innovative and romantic photographs of cars in natural environments. In the 1960s, it was Walker who laid the groundwork for the resurgence of non-silver processes. And today, it is Todd Walker who, through a further expansion of a repertoire that now includes the technologically advanced processes of the computer age, continues to be a vital force in the maturation of the photographic arts.

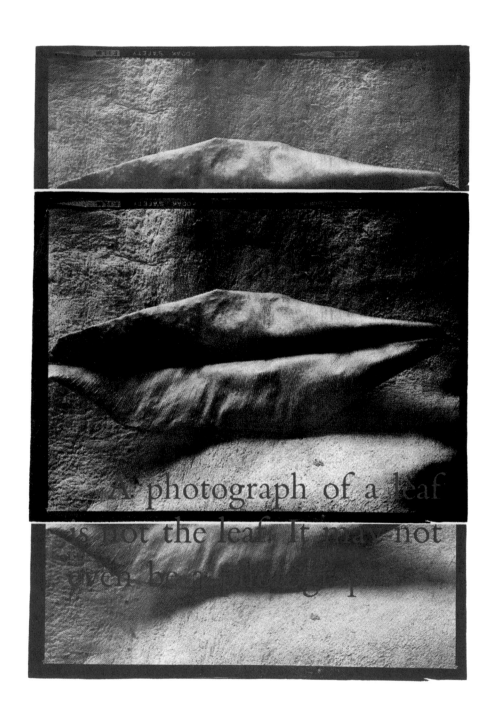

Leaf, 1971. Silkscreen (55.1 × 38.2 cm)

15

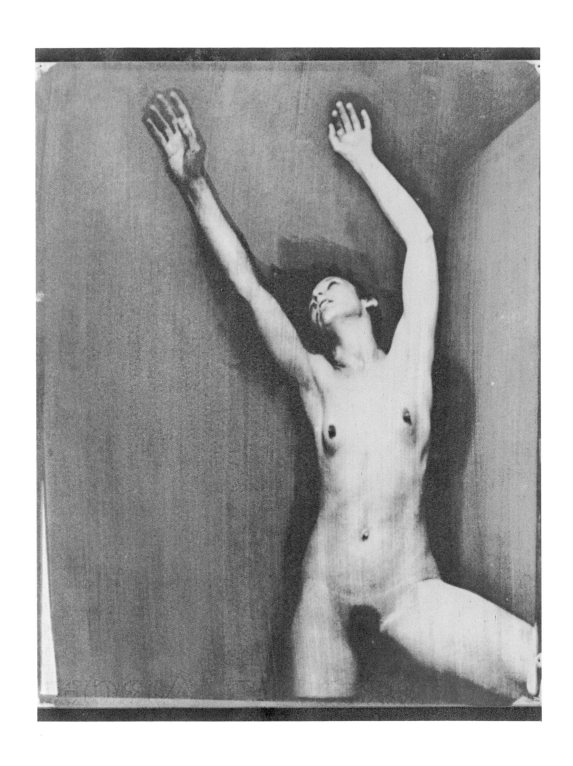

Jacque, 1968. Gum dichromate (24.8 × 19.7 cm)

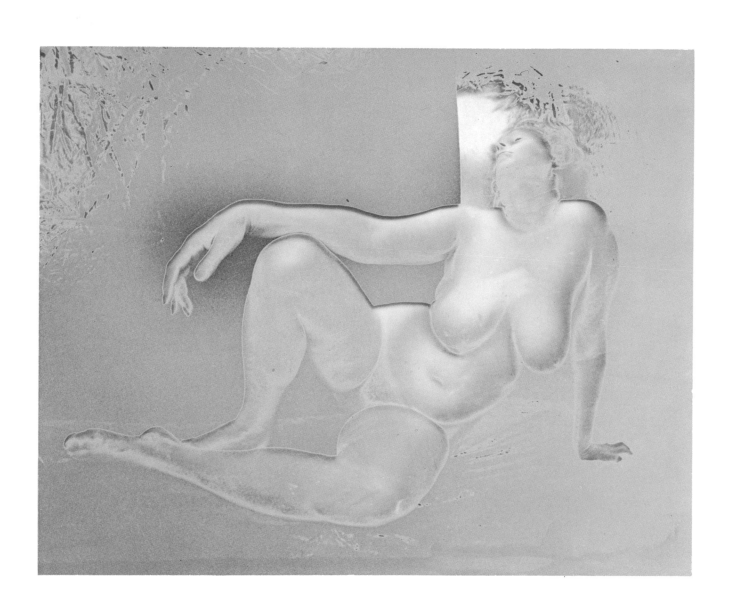

Pearl, 1969. Silver gelatin, Sabattier (19.7 × 24.1 cm)

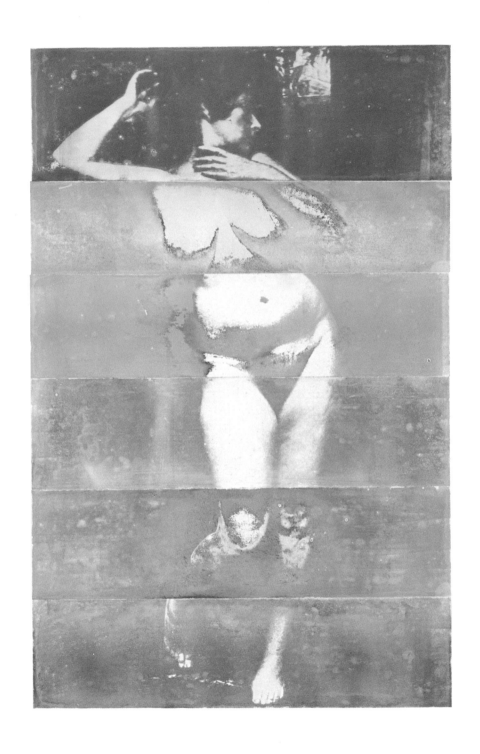

Pearl, 6 flavors, 1969. Collotype (45.7 × 29.8 cm)

18

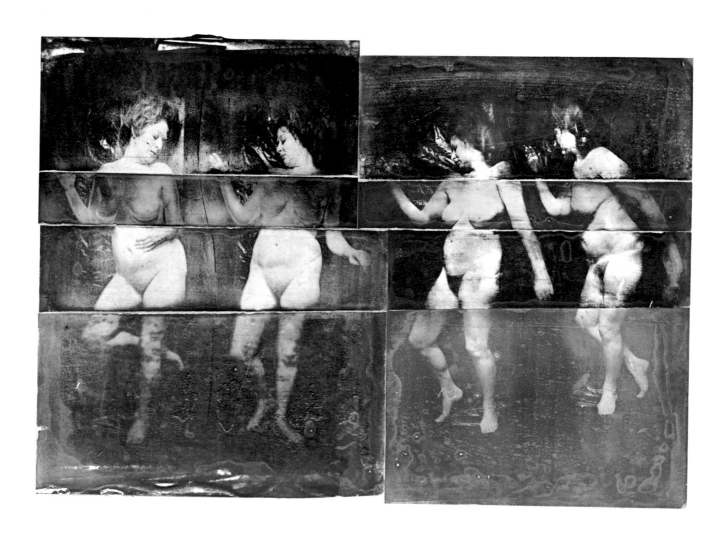

Untitled, 1969. Collotype (26.0 × 36.0 cm)

19

Untitled, 1969. Gum dichromate (26.7 × 20.9 cm)

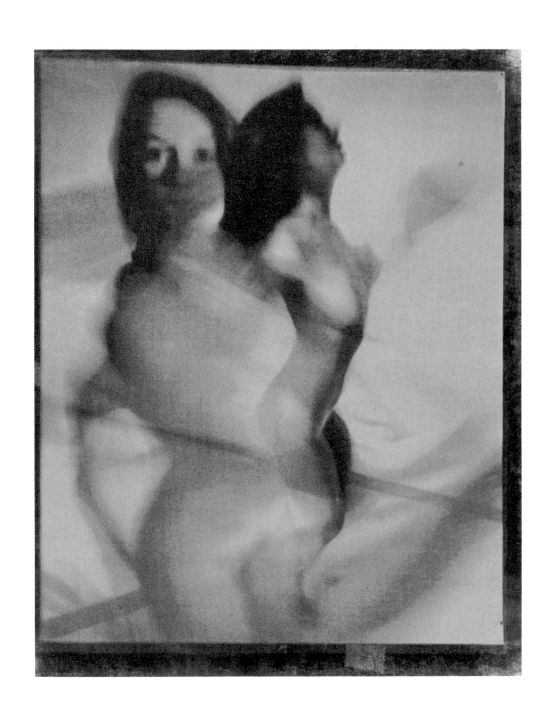

Nancy, 1968. Gum dichromate (26.7 × 21.0 cm)

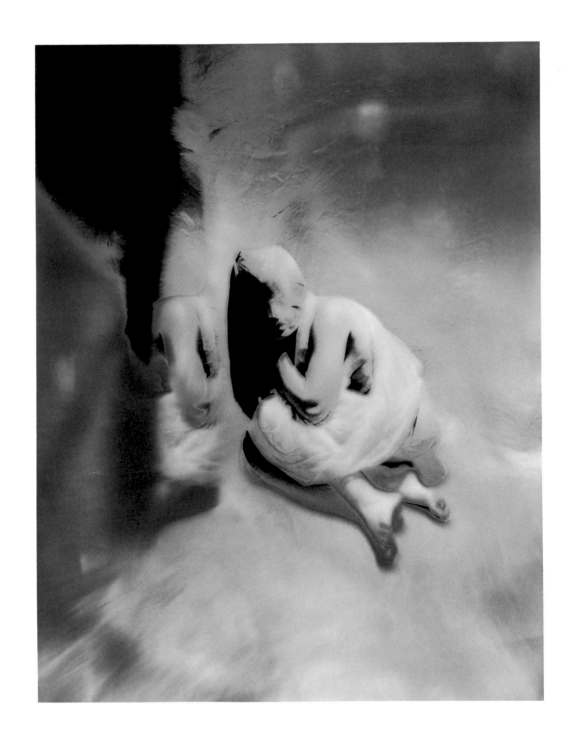

Untitled, 1969. Silver gelatin, Sabattier (23.8 × 18.4 cm)

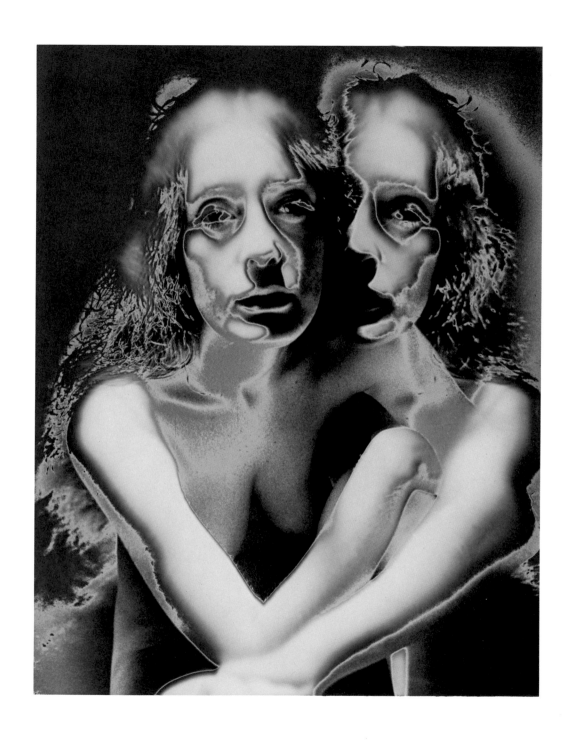

Untitled, 1969. Silver gelatin, color-coupled Sabattier (24.1 × 19.0 cm)

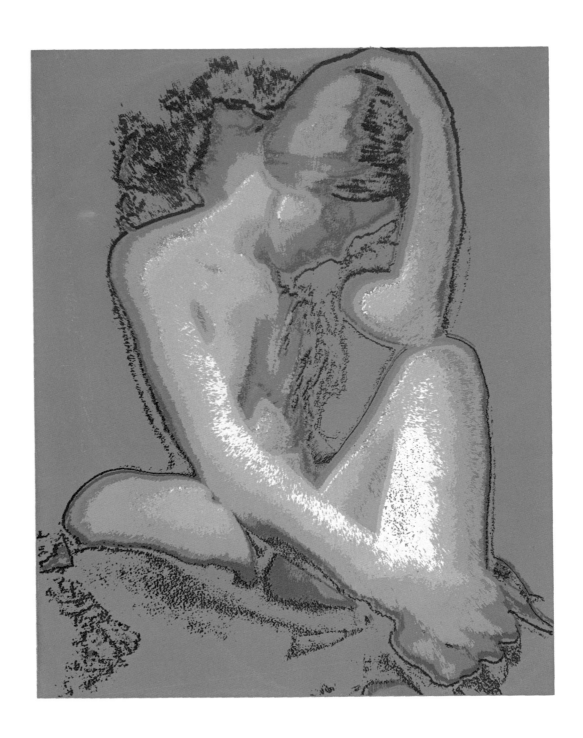

Chris, 1970. Silkscreen (50.7 × 40.5 cm)

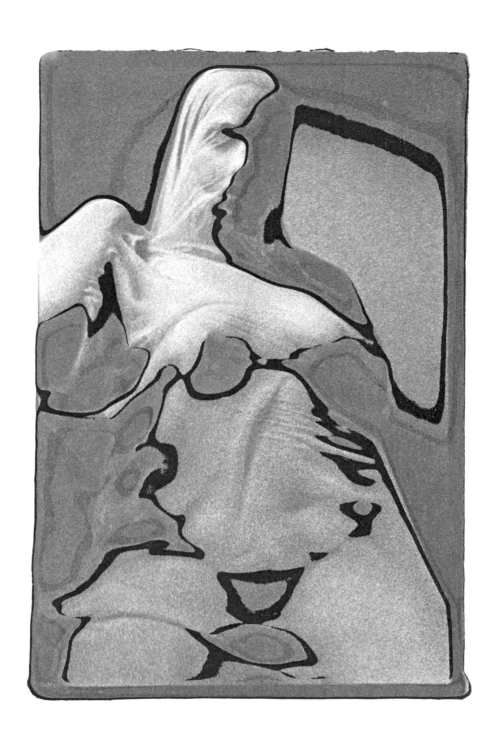

Calligraphic Alice, 1972. Silkscreen (42.0 × 28.0 cm)

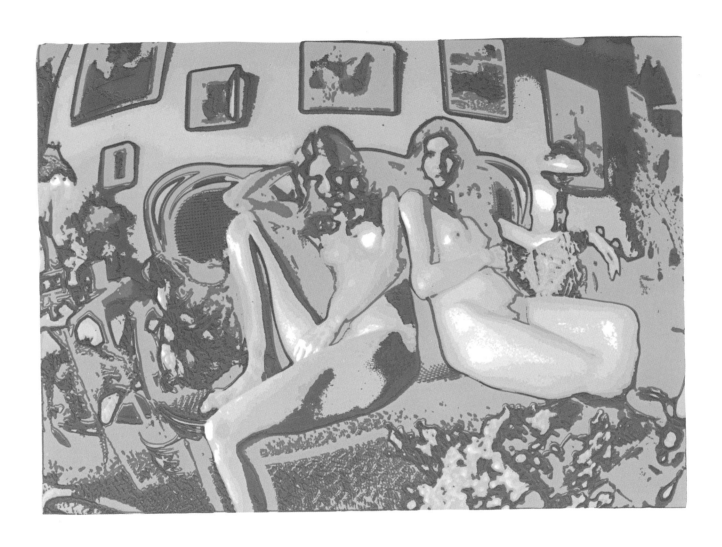

Twins, 1971. Silkscreen (24.2 × 33.5 cm)

26

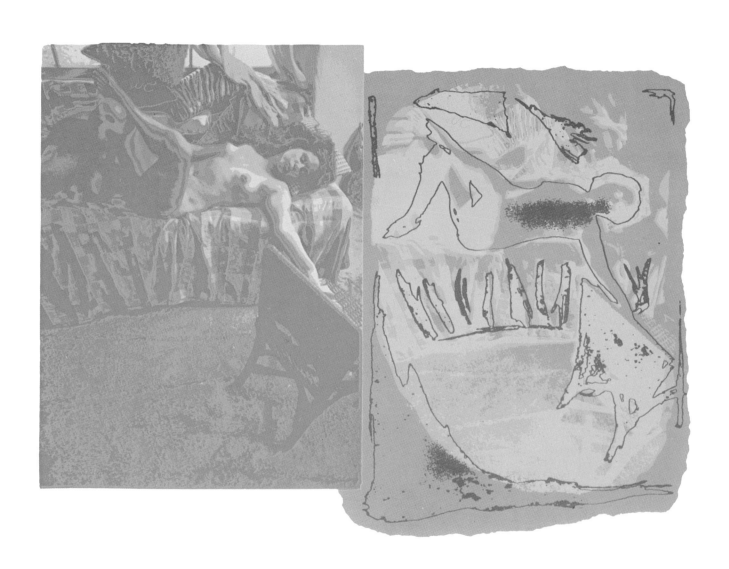

Silkscreen Number 74, 1973. (37.8 × 49.5 cm)

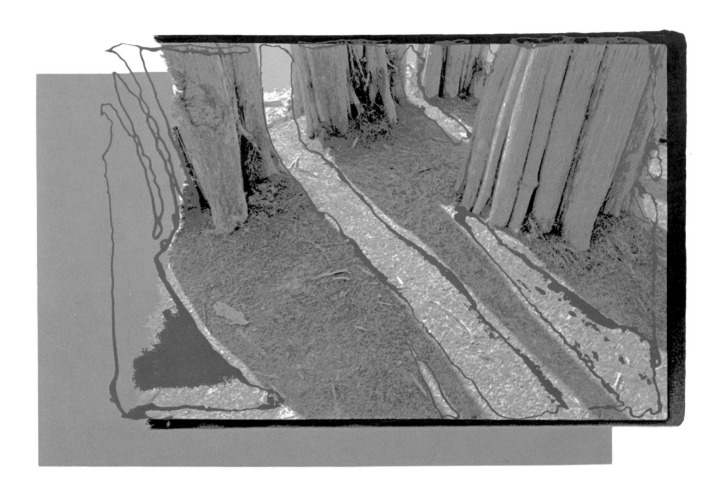

Tallahassee trees, 1973. Silkscreen (38.3 × 58.2 cm)

28

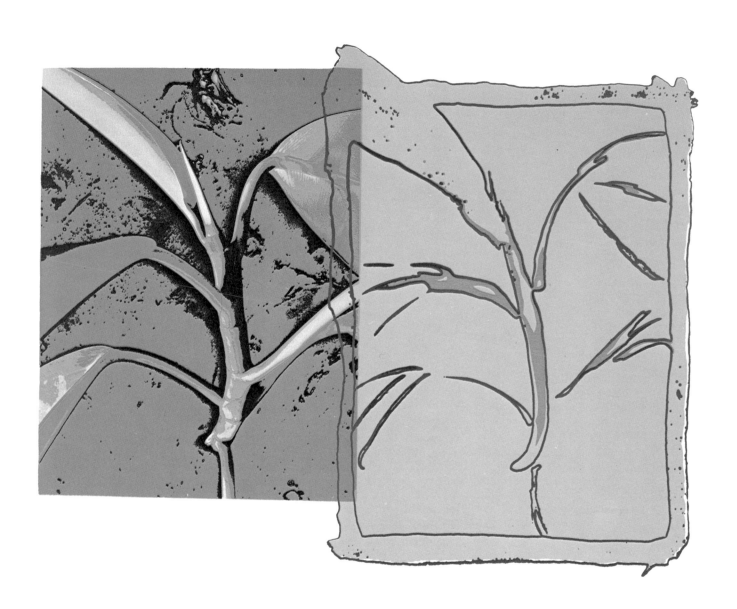

To Linda Connor, 1973. Silkscreen (37.0 × 46.3 cm)

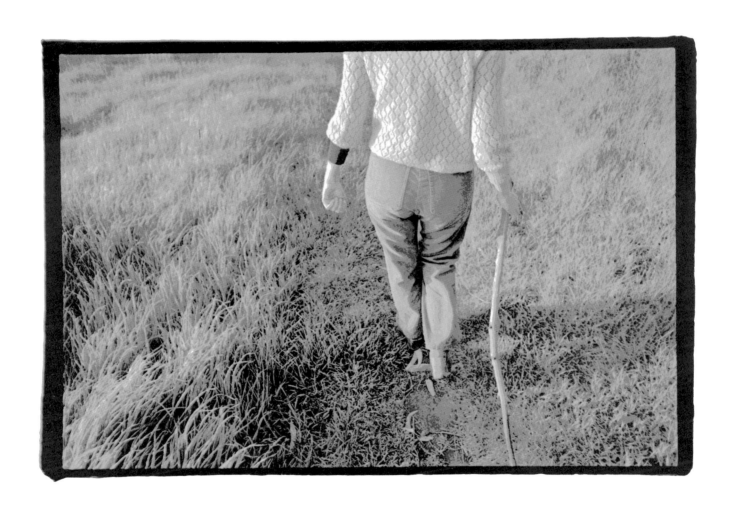

Susie in field, 1975. Silkscreen (32.8 × 49.0 cm)

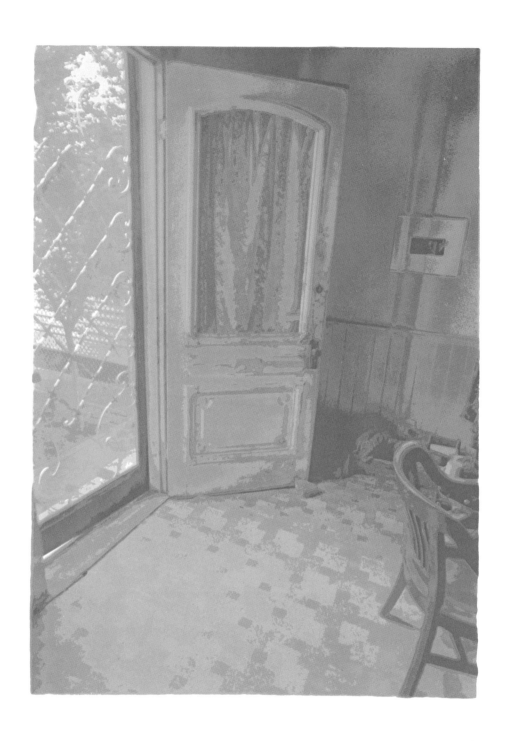

Betsy's door, 1975. Silkscreen (48.4 × 38.6 cm)

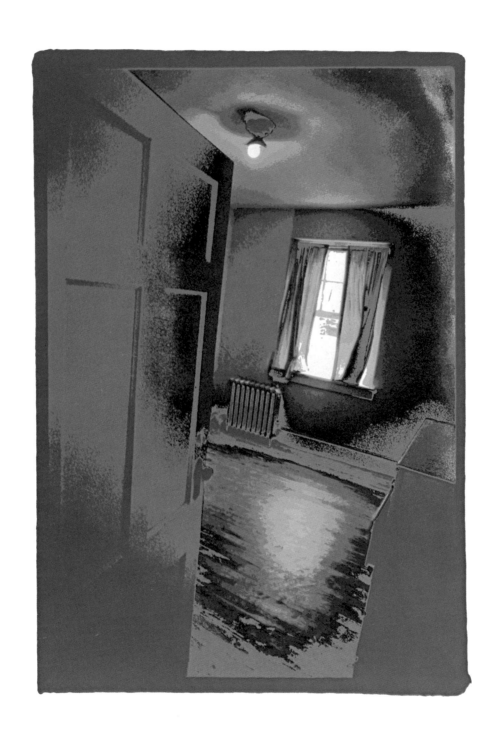

Penland room, 1975. Silkscreen (30.4 × 20.4 cm)

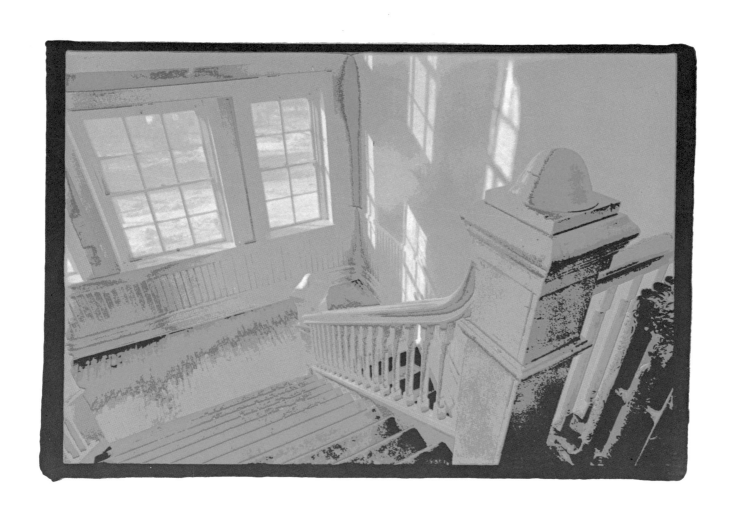

Utah stairs, 1975. Silkscreen (20.7 × 30.7 cm)

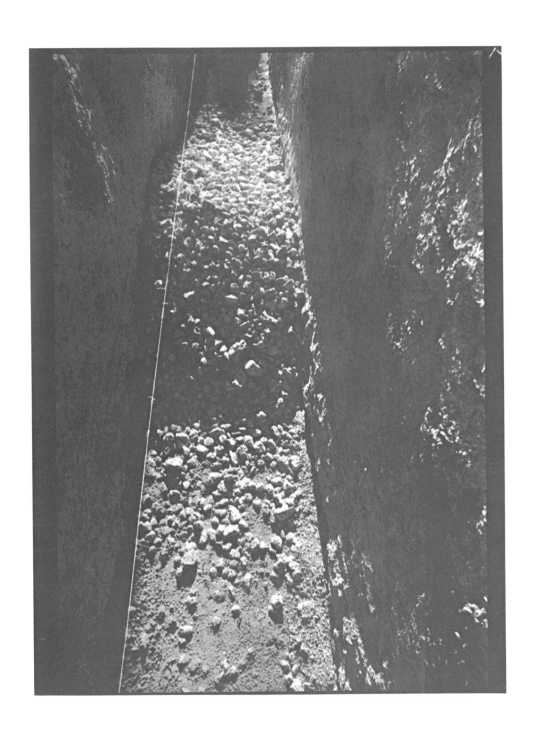

My trench, 1978. Silkscreen (49.7 × 37.0 cm)

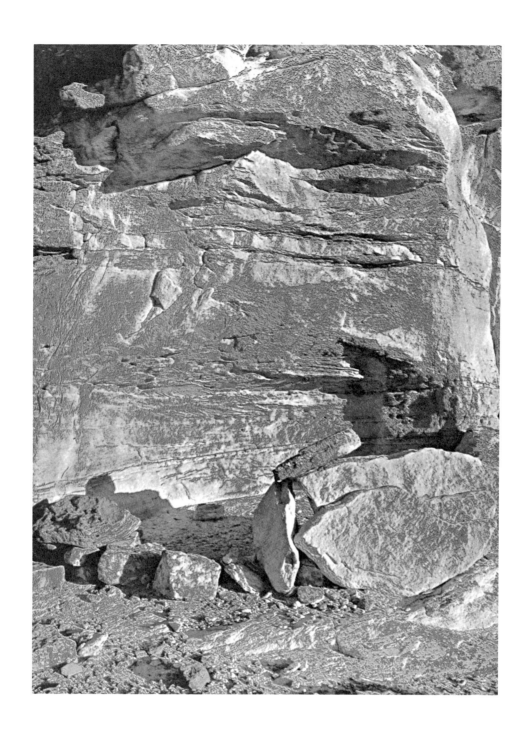

Shrine, 1980. Lithograph (26.9 × 19.5 cm)

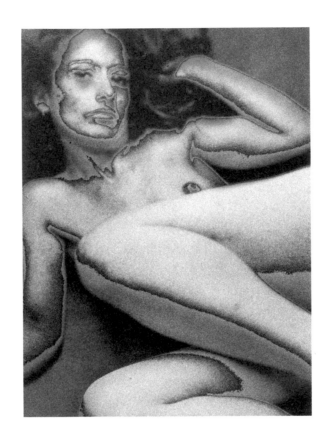

Page 43 from the book *for nothing changes...*, 1976. Lithograph (actual size)

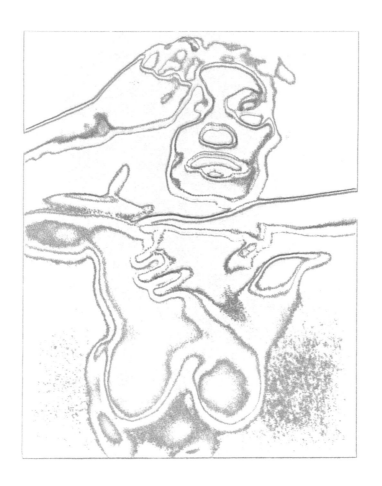

Number 12 from *Portfolio III*, 1969. Lithograph (actual size)

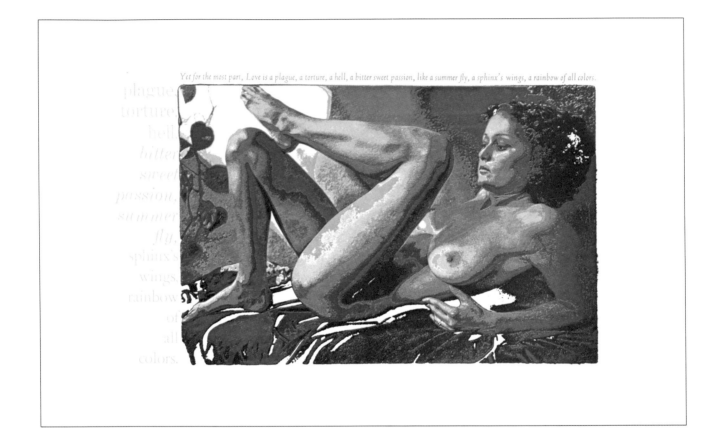

Yet for the most part, Love is a plague, a torture, a hell, a bitter sweet passion, like a summer fly, a sphinx's wings, a rainbow of all colors.

Number 7 from the portfolio *Fragments of Melancholy*, 1980. Lithograph (29.5 × 45.0 cm)

38

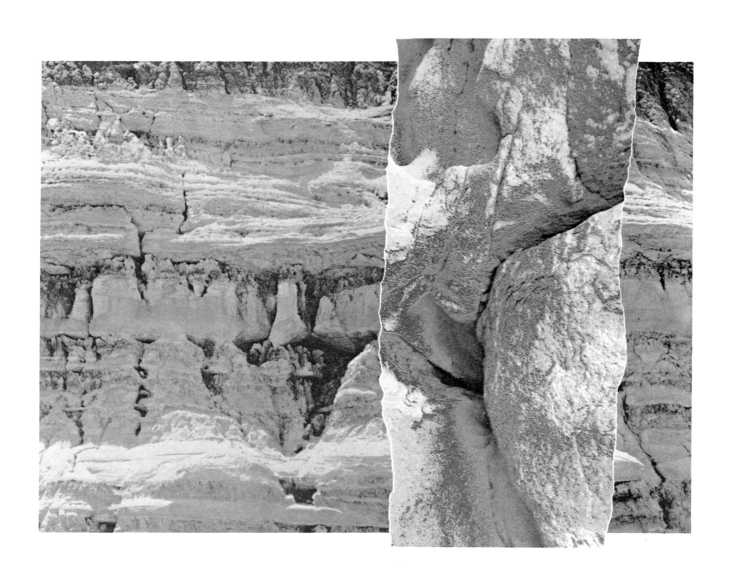

Lithograph Number 169, 1983. (21.0 × 26.9 cm)

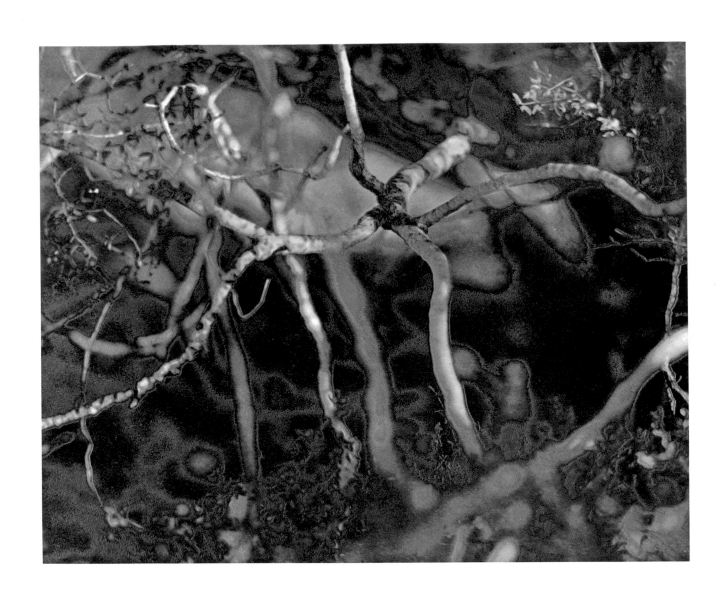

Creosote bush, 1980. Lithograph (22.8 × 28.5 cm)

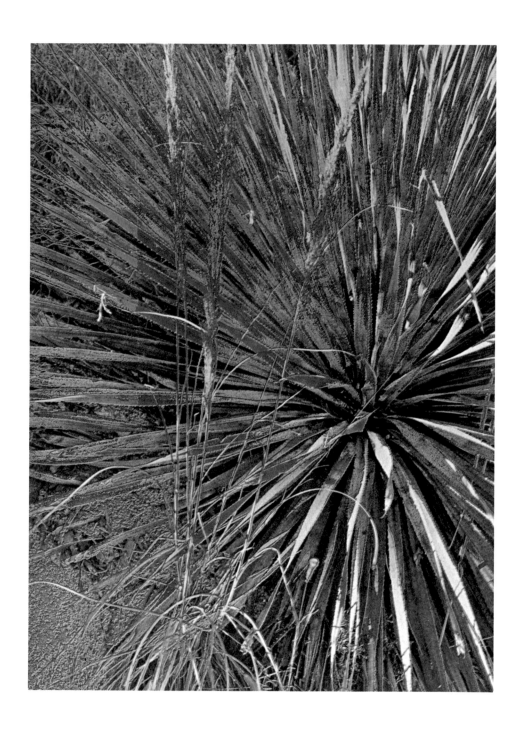

Yucca II, 1981. Lithograph (26.9 × 19.5 cm)

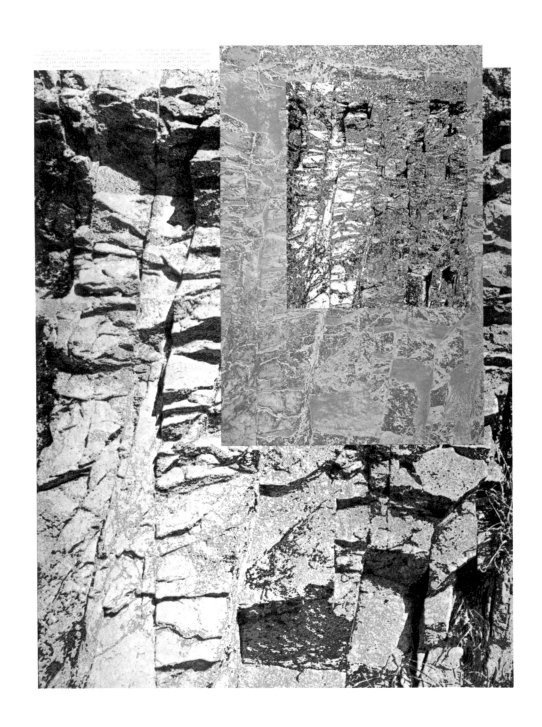

High cliff, 1983. Lithograph (29.0 × 21.5 cm)

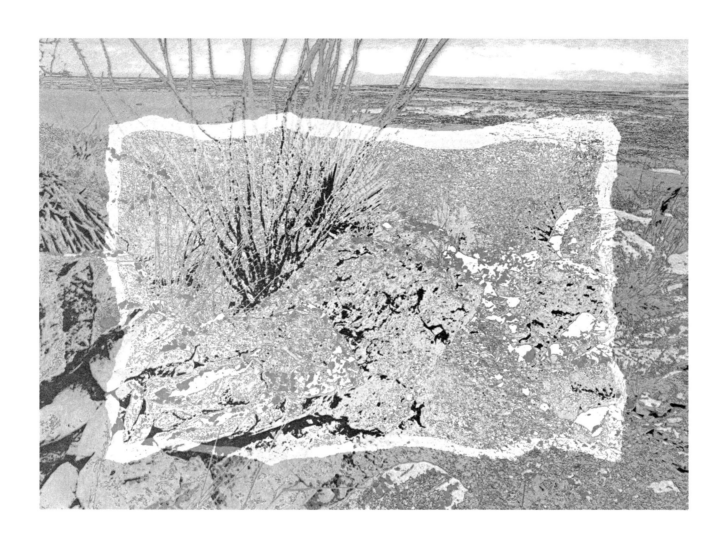

Alamogordo, 1984. Lithograph (20.2 × 27.9 cm)

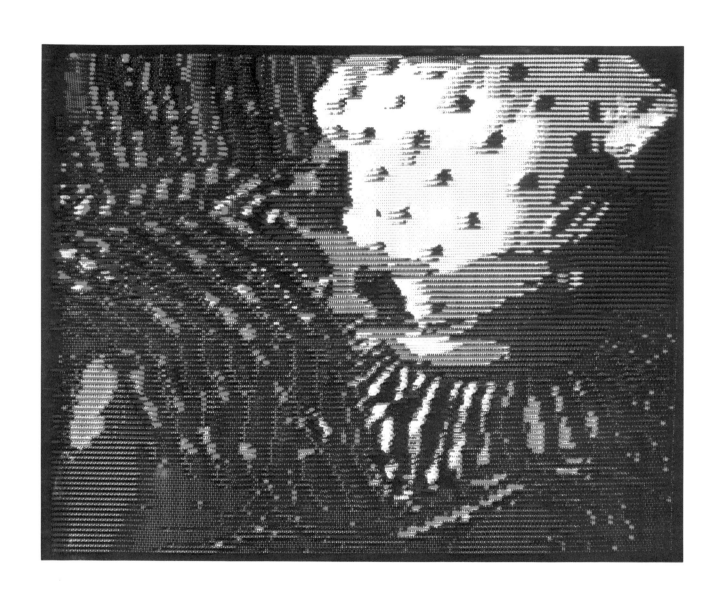

Computer II, 1982. Silkscreen (39.3 × 49.0 cm)

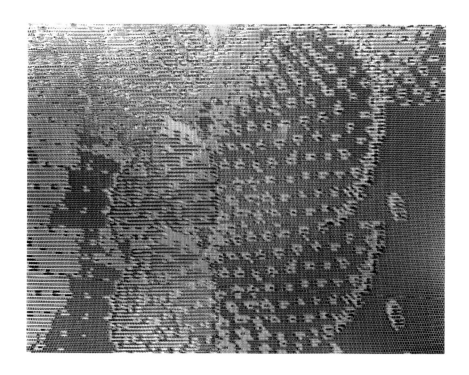

Page 44 from the book *Opuntia*, 1983. Lithograph (actual size)

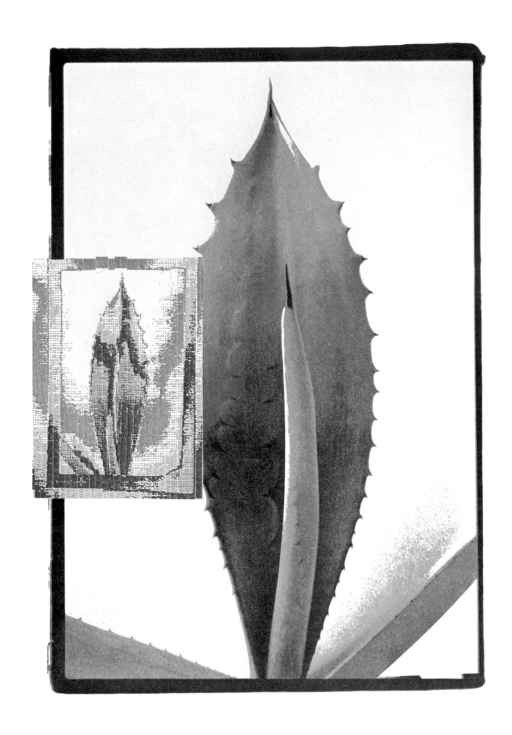

Agave, digitized, 1983. Lithograph (28.5 × 19.8 cm)

46

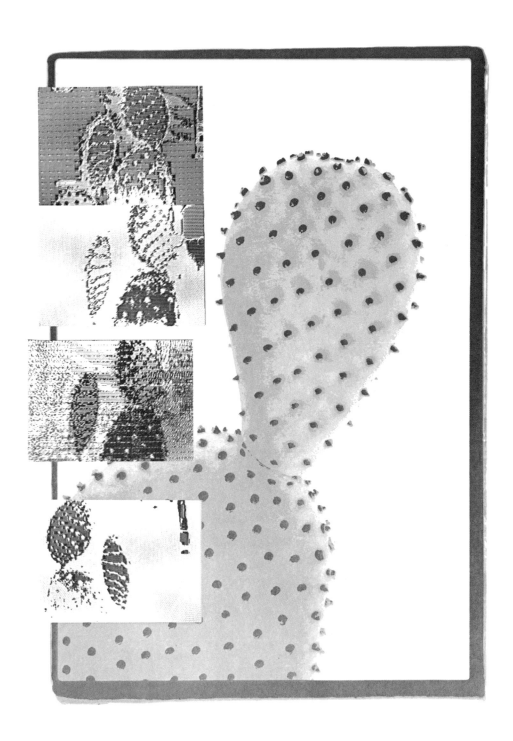

Opuntia, digitized, 1983. Lithograph (28.7 × 19.7 cm)

47